$2.00

STEP BY STEP TECHNIQUES

Calligraphy

GEORGE EVANS

CHARTWELL
BOOKS, INC.

A QUINTET BOOK

ISBN 0-7858-0332-7

This book was designed and produced by
Quintet Publishing Limited

Designer: George Evans
Editors: Robert Stewart, Shaun Barrington
Research: Christine Cash
Photogrpher: Paul Forrester
Jacket Design: Nik Morley
All Calligraphy by George Evans

Typeset in Great Britain by
Central Southern Typesetters, Eastbourne
Manufactured in China by
Regent Publishing Services Limited.

Published by Chartwell Books
A Division of Book Sales, Inc.
P.O. Box 7100
Edison, New Jersey 08818–7100

Contents

INTRODUCTION

Sans
Serifed
Italic
Gothic
UNCIA

Five different lettering styles to be found in this book.

Few people who pick up a calligraphic pen for the first time ever produce a masterpiece. Many are so disappointed with the results that they give up. After all, lettering and calligraphy would appear to be just an extension of handwriting, taught in school. This is far from the truth. Dedication and an appreciation of letterforms and space are essential in this most disciplined of arts.

After leaving school, I was fortunate to be given the opportunity to study graphic design. After only one lesson of tracing letterforms from a printer's specimen sheet, I realized that lettering was by far the most exciting part of the design course. Within a few weeks I was lettering with a brush and pointed pen. It was a further six months before I tried a square-ended nib and calligraphy.

The first serious piece of work I produced was lettered for my grandmother in 1966. I actually spent two weekends before a sheet came off the drawing board which I felt was worth posting to her. It has, however, survived 21 years. At that time, I was not aware of calligraphic styles; so I based the letterforms on a name seen on a perfume bottle. Since then my relationship with and understanding of letterforms has grown stronger.

The work and alphabets included in this book have been reproduced, wherever possible, in their original lettered size, without retouching for the printing process. I hope that this approach will help when studying and assist by giving an honest comparison when checking progress.

Although each letter in an alphabet has its own trait, there are elements that are common to each letter, giving uniformity and continuity to the lettering. It is therefore necessary to become aware of the main characteristics of any given style before lettering is commenced. Examine the round letters; they will all have similarities in weight of stroke and curvature. Likewise a pattern will emerge when comparing both the straight and oblique strokes. The alphabet as a whole should appear as one, without anomalies and in complete harmony.

This book aims to assist the student to become proficient with a pen. More than that, it invites him or her to become aware of the letterforms which surround us all. I firmly believe that speed and ease of learning are of the essence and, providing willingness is there on the student's part, together with patience — as a fair amount of this virtue will be needed – by the end of this book he or she should be well on their way to enjoying the pleasures of lettering.

Over a period of time, the student will develop a warm, personal relationship with letterforms and will become familiar with the individual characteristics of letterforms within the numerous alphabet styles which exist. He may even advance to the point of developing a new style of his own.

Once the inhibitions of committing pen to paper are overcome and confidence starts running, most students wonder how they ever lived without letterforms.

NOMENCLATURE

In order to discuss the subject of letters, calligraphers, letter designers and students require terminology to describe the constituent parts of letterforms. When analyzing a particular style, this nomenclature is used to define the various elements in a concise manner. There is no standard nomenclature to define constituent parts of letters but many of the terms are self-explanatory. The terminology used here is based on that employed by letter designers and therefore may differ from that found in calligraphic references. Many descriptions are repeated from letter to letter as these terms are used generally throughout the alphabet and are not necessarily confined to a specific letter. The parts and names illustrated refer to the Quadrata capitals (majuscule) and a complementary lower-case (minuscule) alphabet although most of the terms can be employed to define other forms.

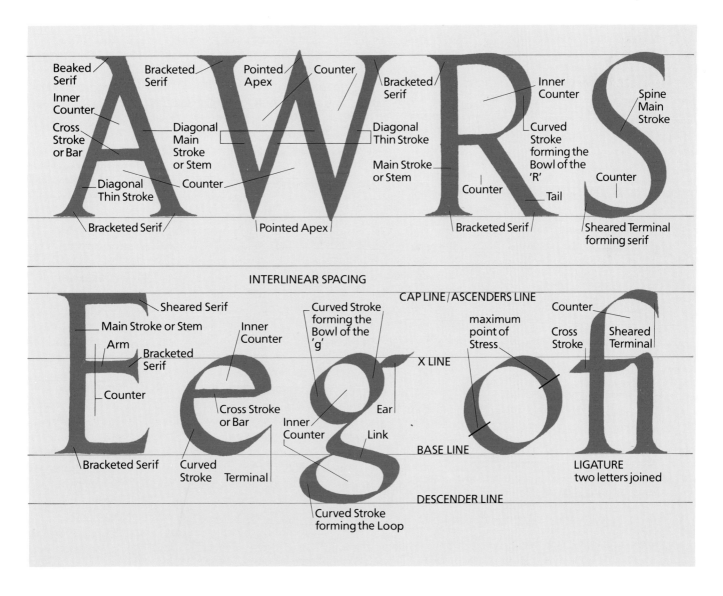

UNDERSTANDING LETTER CONSTRUCTION

Quadrata is the criterion on which all subsequent styles are based. It is therefore of prime importance for students to associate themselves with this fine, proportioned alphabet.

Roman is not just the name of the country of origin but is used more generally to describe any style appearing in a vertical attitude. The capital alphabet contains more straight lines than curves, and many letters have a combination of both vertical and horizontal strokes giving a squarish appearance, hence the word Quadrata. There is an architectural, geometric quality within the style which would account for the harmony created when lettering is used on buildings in stone.

Capital letters can be defined as having a uniform height throughout; that is, they are written between two parallel lines. The letters are contained within a capital line (top line) and a base line, with the exception of the letters 'J' and 'Q' which break the base line in some styles. The lines are also marginally broken by minor optical adjustments to certain letters where pointed apexes and curved strokes slightly overlap.

There are now two fixed points, the capital and the base lines, between which to construct the letters. There is, however, a problem. It must be decided how far apart the lines should be drawn. Consider the proportions of the letters opposite. There is a definite relationship between the capital height and the width of the main stroke. In Quadrata the stem divides into the capital height 10 times, giving a ratio of 1:10. It is important to evaluate this ratio, as misinterpretation will result in an untrue reproduction of the style.

Once the height and weight ratios have been established, consideration must be given to the construction of individual letters. The Romans were a practical and efficient race, and their ability to rationalize and organize is reflected in the formal appearance of their design. The alphabet which follows has been produced with a pen and is based on formal Roman characters. If the forms are analyzed, it will be noticed that there are similar characteristics between certain letters, the 'E', 'F' and 'L' for example.

It is also apparent that the widths of letters are not identical and that each character occupies a given area in width while retaining a constant height. This width is known as the unit value of the letter, the 'M' and 'W' being the widest and the 'I' and 'J' the narrowest. The unit width is a necessary factor in determining the final balance and poise of letters.

When letters are placed on a gridded square, an immediate visual comparison between the letterforms is possible. The grid illustrated has been divided into units of stem width for convenience, giving an initial square for the capitals subdivided into 10 units of height by 10 units of width. The lower blank portion is for the lower case letters, which appear after the capitals. The lower portion will then be used to accommodate the descenders of the lower case.

Incidentally, the words 'lower case' are a printers' term, now in common use to describe minuscule letters. It derives from the typesetters' cases which contained the metal or wooden letters. The capital letters of an alphabet were stored in the upper case and so are sometimes referred to as such, with the small letters stored in the lower case.

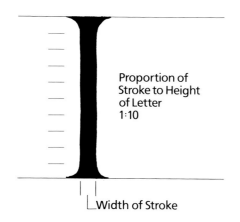

Proportion of Stroke to Height of Letter 1:10

Width of Stroke

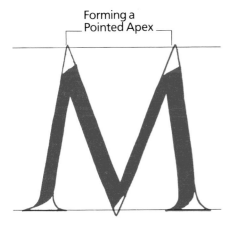

Forming a
Pointed Apex

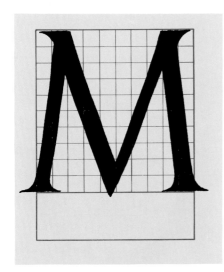

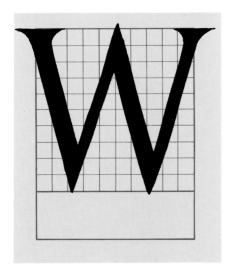

Although concerned with calligraphy here, I feel that the common terms for majuscule and minuscule letters – capitals and lower case – are better employed and I will use this terminology from now onwards.

When analyzing the construction of individual characters, it is essential for the student to fix their images firmly in his mind. The proportions of this style will be found to be indispensable as the student becomes more involved with letterforms, and the ability to draw on his experience of the classical Roman style will assist him when analyzing other letterforms. The letters fall into six groupings, from the widest to the narrowest characters.

I have lettered this alphabet with a pen to illustrate proportion; it also shows that a classical Roman style can be achieved calligraphically. It is not my intention that the student begins lettering with this style. The construction of the letterforms is difficult in as much as they are not easily reproduced with a square-ended nib. Within the sample alphabet sheets there is a Roman style that has been simplified for use with the pen. Even so it will be seen that it is deliberately the last alphabet entry and therefore requires a degree of penmanship.

ROMAN CAPITALS

Group 1
The 'M' is one of the widest letters of the alphabet, occupying slightly more than the square with the diagnoal strokes breaking the grid at both sides. The true Roman 'M' has pointed apexes, along with the 'A' and 'N', which are easily cut with a chisel; but when a pen or brush is employed, other forms of ending the strokes are more natural.

In order to achieve a pointed apex the pen strokes end short of the cap and base lines and are then brought to a point. The apexes project beyond capital and base lines in order to obtain optical alignment with letters ending in square terminals or with beaked or bracketed serifs. Because the apexes of the 'M' in the example alphabet end in a beaked serif, this will naturally be carried through to the 'A' and 'N' to give continuity. The straight, thin strokes in the 'M' and similar letters are approximately half the thickness of the main stroke, but these strokes do alter because of the fixed lettering angle of the pen in relation to the direction of the strokes.

The 'W' is perhaps the widest letter of the alphabet. It does not appear in Roman inscriptions but is a medieval addition to the alphabet. In Latin inscriptions 'V' stood for both the 'U' and 'V' sounds – hence the name 'double U', drawn as two 'V's virtually joined together, with minor adjustments. The 'U' symbol was a later development, perhaps to avoid confusion.

Group 2
The 'O' sets the standard for all curved letters and the 'Q' can be said to be an 'O' with an added tail. It is advisable to make note of the point at which the tail joins the curved stroke. Some letters, unfortunately, have a tail which appears to emanate from the lower left-hand curve of the letter, as

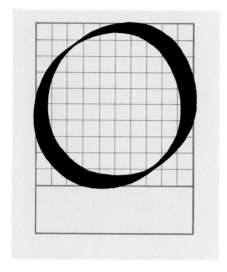

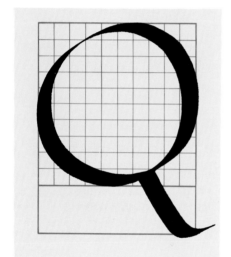

an extension. This, in my view, is undesirable as the tail is most definitely a separate stroke.

The widest point of the thick stroke of the 'O' is marginally wider than that of the stem of the 'I'. In a free-drawn letter, that is a letter drawn and then filled in, this is an optical adjustment made to compensate for the tapering or thinning of the stroke towards the thinnest part of the letter. Without this alteration the curved stroke would appear optically thinner than the stem of the 'I'.

In calligraphy, the adjustment to thicken the curved strokes is automatic because of the oblique angle of the pen to the direction of writing. The thin strokes are substantially thinner than half the width of the main stroke, due to this same action of the pen. If desired, these thin strokes can be thickened to compare more favourably with the straight thin strokes. I have not done so, because I feel the characters should reflect the nature of the tool.

The widest point of the curved stroke is known as the 'maximum point of stress' and in this example it can be said that the letter has diagonal stress with oblique shading. There are many styles which have horizontal stress with vertical shading.

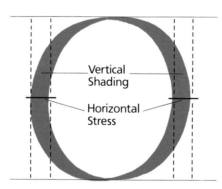

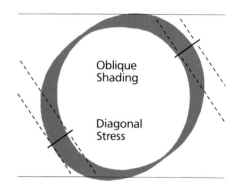

Group 3

The 'C', 'D' and 'G' take up about nine-tenths of the width of the gridded square. Because they are all rounded forms, the top and bottom curves project slightly over the cap and base lines. This is to ensure that the round letters appear the same height as those ending in flat serifs. Without this refinement they would appear smaller.

The 'C' follows the left-hand curve of the 'O', but the upper and lower arms are somewhat flattened. The upper arm ends in a sheared terminal which is slightly extended to form a beak-like serif. In Quadrata the lower arm also ends similarly. This serif is extremely difficult to produce with a pen.

'G' follows the lines of the 'C', with the stem of the 'G' rising from the lower arm to within five-tenths of the letter height and terminating in a bracketed serif. I prefer the stem slightly shorter at four-tenths.

'D' follows the right-hand curve of the 'O' with the upper and lower curves extending from the initial cross-strokes, so slightly breaking the cap line and base line. The stem appears slightly thickened towards the base cross-stroke where it is joined with a curved bracket. The serifs are bracketed on the left hand of the stem.

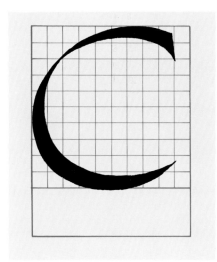
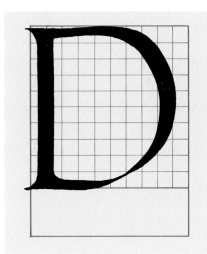
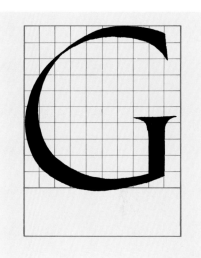

Group 4

This is the largest group of letters and includes 'A', 'H', 'K', 'N', 'R', 'T', 'U', 'V', 'X', 'Y' and 'Z', all of which occupy approximately eight-tenths of the gridded square.

The 'A', 'V', 'X' and 'Y', being letters formed from triangular elements, should appear almost symmetrical. The 'V' and inverted 'V' shapes should be balanced, not leaning to right or left. The cross-stroke of the 'A' is positioned midway between the apex and the base line.

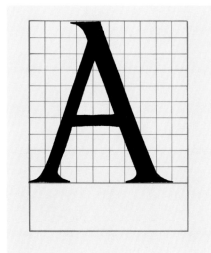
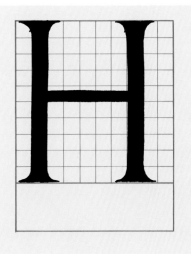
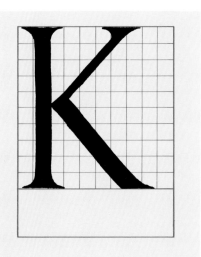

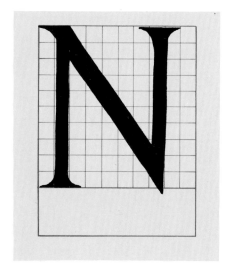

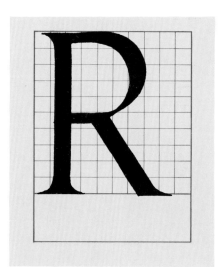

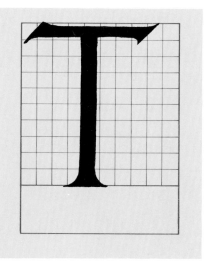

The cross-bar of the 'H' should be slightly above the centre line; otherwise it seems to be slipping down the main stems. The two diagonal strokes of the 'K' meet at a point which, too, is slightly above the centre, making the lower counter fractionally larger than the upper counter.

The pointed apex of the 'N' should protrude below the base line with the upper left-hand serif being beaked. Both the upper part of the bowl of the 'R' and the curved stroke of the 'U' project above the cap line and below the base line respectively. The top of the lower cross-stroke which joins the bowl of the 'R' is positioned on the centre line. A careful note should be made as to where the tail of the 'R' meets the bowl.

The cross-bar of the 'T' is sheared to the lettering angle on the left and right sides, ending in a slight serif. The spurs added to the serifs protrude above the cap line.

The 'Z' is a problem letter as the main diagonal stem requires a change of pen angle to thicken the stroke. Otherwise the stem would appear as a hairline-thin stroke. This makes it difficult to execute with the pen.

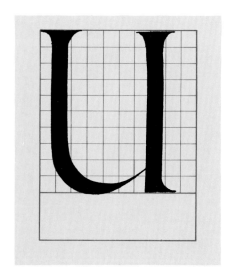

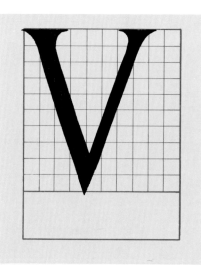

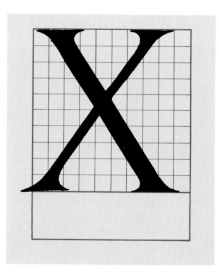

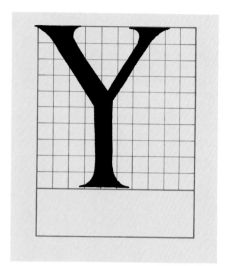

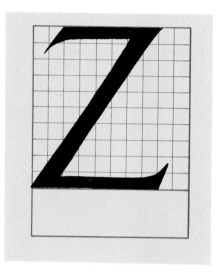

Group 5

Within this group are the letters 'B', 'E', 'F', 'L', 'P' and 'S', each letter occupying about half the width of the gridded square. The upper bowl of the 'B' is smaller than the lower and therefore the intersection is above the centre line. This is intentional: if both bowls were equal in size the letter would appear top-heavy.

The upper arm of the 'E' is slightly longer than the middle arm, which is placed high on the centre line, making the upper counter smaller than the lower. Again this is optically necessary. The lower arm projects a little beyond the upper arm with both ending in sheared, bracketed serifs.

The 'F' may be regarded as an 'E' minus the lower arm. The 'L' is an 'E' without the upper arms. The stem at the cap line has the addition of a bracketed serif on the right.

The letter 'P' at first glance resembles a 'B' minus the lower bowl. Closer inspection will show that the bowl is larger than the upper bowl of

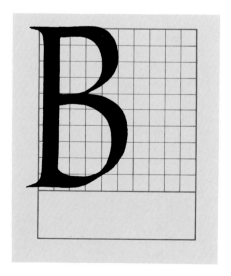

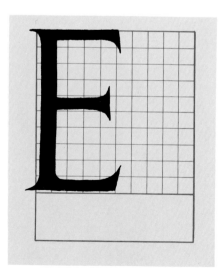

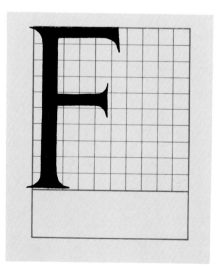

'B'. The cross-stroke joins the bowl to the stem below the centre line.

The upper counter of the 'S' is smaller than the lower counter, with the letter sloping slightly to the right. The diagonal spine is of uniform thickness until it tapers to meet the curved arms. The 'S' is a diagonally stressed letter, having this characteristic in common with the 'A', 'K', 'M', 'N', 'R', 'V', 'W' and, in this alphabet, the 'Z', which is the only letter with a thick diagonal stroke running from top right to bottom left. The upper and lower arms end in sheared terminals and fractionally extend to form beak-like serifs. Being the only letter with diagonal stress it is important for balance that the lower counter is slightly larger than the upper counter. This gives the 'S' a slight forward tilt, making it one of the hardest letters in which to achieve good poise.

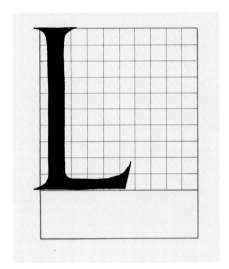 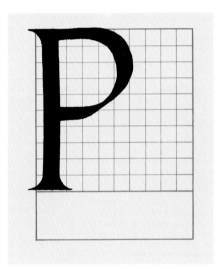 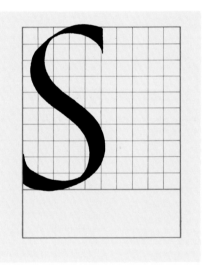

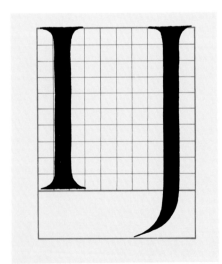

Group 6

The 'I' and 'J' take up approximately three-tenths of the gridded square. The 'I' is a simply constructed letter. Nevertheless, it is important because it sets the standard for the alphabet in height and stem width.

The 'J' does not appear in the inscription on the Trajan Column where its present-day sound is represented by an 'I'. 'J' is written like an 'I' minus the base-line bracketed serif, where the stroke continues through the base line and curves to the left, ending in a pointed terminal. The length of the stroke is contained within the descender area.

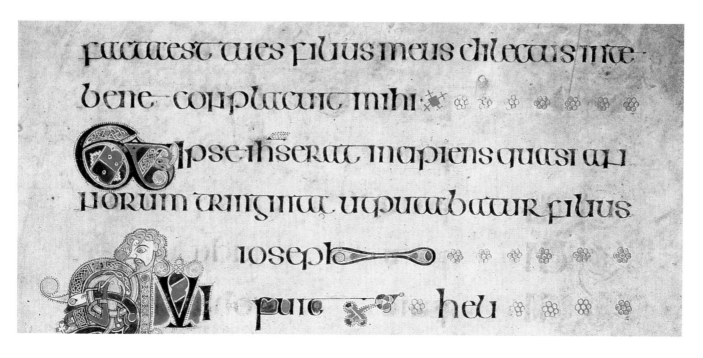

THE DEVELOPMENT OF LOWER CASE (MINUSCULES)

The Quadrata and Rustica capitals were followed by Uncial, born of the need to write more quickly while still maintaining a formal style. Uncial is a true pen form with a simple construction and comparatively clean finishing strokes. Uncial was the literary hand for fine books from the fifth to the eighth century. The letterforms were more rounded than traditional Roman capitals. The chief characteristic letters within the style were the 'A', 'D', 'E', 'H' and 'M' and, although they were still written between the capital and base lines, certain letters, namely the 'D', 'F', 'G', 'H', 'K', 'L', 'P', 'Q', 'X' and 'Y', began to have longer stems which marginally broke through the cap and base lines.

Uncial was followed by Half-Uncial and here some letters are seen predominantly to break through the writing lines forming ascender and descender areas. Letterforms were modified, notably the 'a', 'b', 'e', 'g' and 'l', with the remaining letters receiving only minor amendments, if any at all. Half-Uncial led the way for other minuscule scripts to be developed.

Towards the end of the eighth century, with the revival of learning, came a reform of the hand in which works of literature were to be written. The emperor Charlemagne, who governed a vast area of Europe, commissioned the abbot and teacher, Alcuin of York, to rationalize and standardize the various minuscule scripts which had developed. Alcuin studied the former styles of Quadrata, Rustica, Uncial and Half-Uncial and developed a new minuscule as a standard book style. This has become known as the Carolingian minuscule after its instigator, the emperor Charlemagne. Calligraphy now entered a new era with this distinctive true pen form.

A comparison of the Uncial and Half Uncial letterforms.

An example of Uncial and Half Uncial lettering from the Book of Kells.

Although the Romans used mainly capital letterforms, I have included a classical lower-case alphabet, together with Arabic numerals, to complement the capital forms previously described, and to give the student an insight into their construction. The letters and numerals that follow are of classical proportions and, once their relative widths and construction details have been mastered, knowledge of them will stand the student in good stead for lettering the sample alphabets in this book.

The letters have been placed on a grid which consists of squares of stem width: thirteen units deep, with four units allocated for the ascenders (those letters which reach the cap or ascender line, the 'h' for instance), six units for the x height (that portion of the grid which contains letters such as the 's') and three units below the x height (to accommodate the descenders of letters such as the 'g' and 'y'). I have grouped together the characters with common widths, starting with the widest and ending with the narrowest.

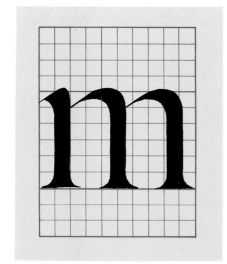

Group 1
The lowercase 'm' and 'w' occupy approximately 10 units, and both letters are contained within the x height. In the 'm', observe the point at which the curved shoulder of the second stroke meets the stem of the first — the second shoulder intersects at the same height. The serif of the first stroke and both shoulders, because they are curved, are positioned so that they break the x line to give optical alignment with the letters 'v', 'w', 'x', 'y' and 'z'; their tops are either bracketed serifs or, in the 'z', a cross-stroke.

The 'm' is not two 'n's joined, as the inner counters of the 'm' are narrower than that of the 'n'. The apexes of the 'w' extend slightly below the base line and the inner apex is the x line. This shows that the diagonal strokes are positioned correctly.

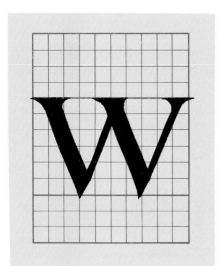

Group 2
Each letter in this group occupies about seven units. The group comprises 'd', 'g', 'h', 'k', 'n', 'p', 'q', 'u', 'x' and 'y'. There are three letters with ascenders ('d', 'h' and 'k'), four letters with descenders ('g', 'p', 'q' and 'y'), and three contained within the x height.

In the 'd', at the point where the lower curve of the bowl meets the main stem, there should be a triangular space formed by the upward movement of the curved stroke. The upper serif of the main stem projects slightly above the ascender or cap line.

The old-style 'g' is very difficult to master. In this style the bowl does not take up the whole depth of the x height: instead it occupies just over three units. It then joins the link which carries down to the base line and then turns sharply to the right and ends forming the right side of the loop. The loop is accommodated within the three-unit descender area. The ear is attached to the bowl at the right side, leaving a v-shaped space.

The 'h' and 'n' are formed in a similar fashion, although the 'h' has the first stem lengthened to form the ascender, with the serif extending over the ascender line. The letter 'n' can be taken as an 'h' without the ascender. The ascender stem of the 'k' is like the 'h' and the diagonal thin stroke and the tail intersect just above the centre of the x height.

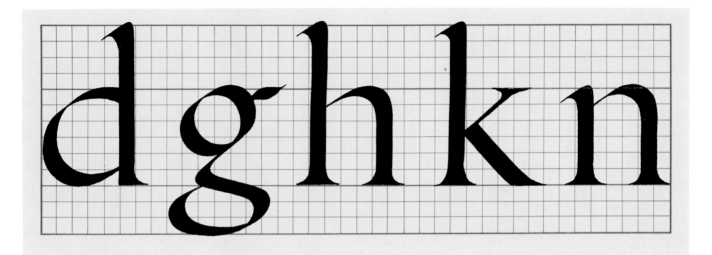

With the 'p', the join of the lower part of the bowl to the stem is somewhat flattened. A serif is attached to the bowl at the top left-hand corner. The 'q' is not a 'p' in reverse but is totally different in character, having no serif at the x line and with the upper stroke of the bowl being straightened to meet the stem.

The 'u' is not an inverted 'n'. The upper serifs protrude beyond the x line and a space is left where the curve makes its upward movement to meet the second stem. In the 'x', the point of intersection of the thin and thick strokes is above the x-height centre, making the lower counter larger than the upper. The diagonal thick stroke of the 'y' does not reach the base line but is intersected by the thin stroke, which follows through to the descender line where it ends in a flat, bracketed serif.

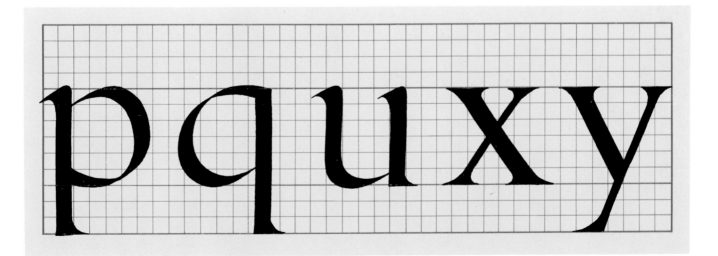

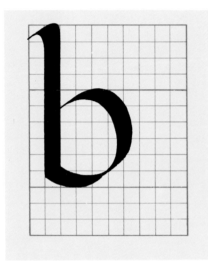

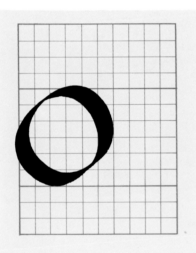

Group 3
The two letters in this group take up approximately six-and-a-half units in width. The 'b' is an ascending letter, the main stem swinging to the right before it meets the base line. The 'o' is contained within the x height with the exception of minor optical adjustments at the x and base lines.

Group 4
This group contains the 'a', 'c', 'e', 'f', 'v' and 'z' and, with the exception of 'f', they are all contained within the x height.

The 'a' starts from a pointed, curved arm which leads into the main stem. The bowl starts from the stem above the centre line of the x height and moves to the left before the downward curve. It rejoins the stem above the base line, leaving a triangular shape. The 'c' follows the left-hand stroke of the 'o', the upper arm being slightly straightened and ending in a sheared terminal which is extended to form a beak-like serif. The lower arm ends in a pointed terminal. The 'e' follows the 'c'; the upper arm, however, is not straightened but flows round. I end the stroke obliquely. The bowl is formed by a cross-stroke which is positioned above the x-height centre.

The 'f' is an ascending letter, starting its main stroke below the ascender line with the arm projecting to the right and ending in a sheared beak-like serif. The cross-bar is positioned just below the x line. The 'v' and 'z' both follow the same construction as their capital counterparts.

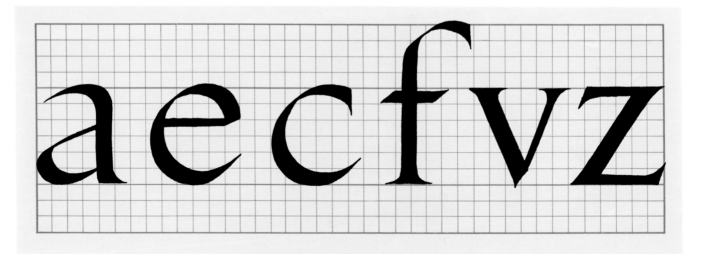

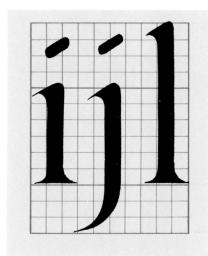

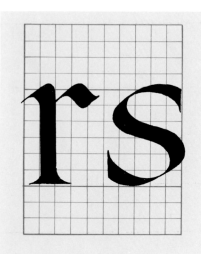

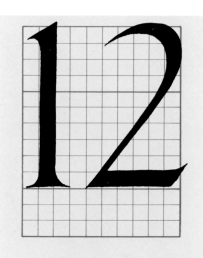

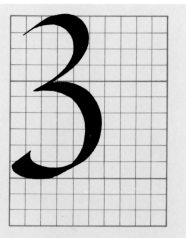

Group 5

This grouping contains three characters, about five units wide: the 'r', 's' and 't'. From the main stem of the 'r' there is a small shoulder stroke which should not be overdone — if it is too long it can interfere with the lettering of the character which follows. The 's' is constructed in the same manner as its capital.

The main stem of the 't' starts obliquely, a little way above the x line, moving to the right before reaching the base line and ending in a pointed terminal. Like the 'f', the cross-stroke is finished with a slight upwards movement.

Group 6

The 'i', 'j' and 'l' fall into this narrow-letter group. They are easily constructed, with the humble 'i' and 'l' setting the pattern for straight letters. The dot over the 'i' and 'j' can be round or flat and is usually positioned about midway between the x and ascender lines. The 'j' initially follows the 'i' but extends below the base line where it curves to the left, ending in a pointed terminal.

NUMERALS

The Romans used letters of the alphabet for their numeric reference. We are all familiar with the Roman-style numerals when applied to a clock face, but perhaps not so with M = 1,000, D = 500, C = 100 and L = 50. It takes little imagination to see that mathematical calculations could be made easier by changing the symbols. The Arabs did exactly that and based their system on 10 numeric signs, the 'Arabic numerals' we use today. They can be either of uniform height ('lining numerals') or of varying height ('old style' or 'hanging numerals'). In the latter style the 1, 2 and 0 appear within the x height, the '6' and '8' are ascending numerals and the 3, 4, 5, 7 and 9 are descending characters.

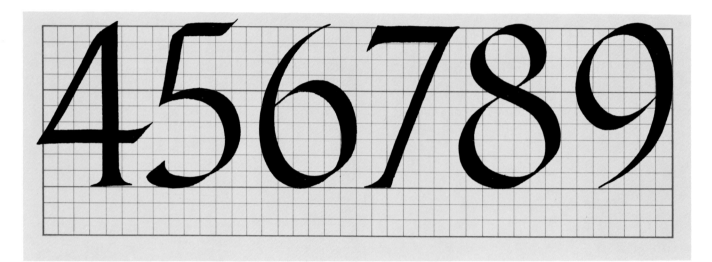

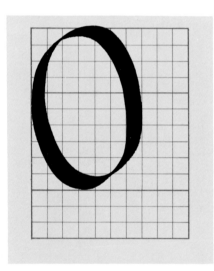

The main characteristics of the numerals need little explanation, but a few points should be noted. For example, if numerals are not constructed carefully they can appear to be falling over. This, I feel, is because they are mainly asymmetric in form, with the exception of the 0, 1 and 8, which are basically balanced.

If the curve of the 2 is allowed to project beyond the base cross-stroke, it will appear to be leaning to the right. If the tail of the 9 is not carried sufficiently far to the left, the figure will appear to lean to the left; if too far, it will look as if it is leaning to the right. The 9 is not an inverted 6. The join of the small curved stroke to the main curved stem alters in each case, making the inner counters slightly different in shape.

The upper counters of the 3 and 8 should be smaller than the lower; otherwise the characters will be top heavy. The cross-bar of the 4 is fairly low on the stem so that the inner counter does not appear too small. The diagonal stroke of the 7 cannot extend too far to the left: once it goes beyond the alignment of the upper stroke, it makes the letter look as if it were leaning backwards. If the cross-stroke of the 5 is too long, it too can appear to lean to the right. Finally, it should be noted that the numeral 0 is compressed and not a letter 'O'.

Within our written language there are of course many other symbols such as parentheses, exclamation marks and question marks, to name but a few. These will become natural enough to create once the student starts practising calligraphy.

The character '&' is known as the ampersand. This is possibly a corruption of the mixed English and Latin phrase 'and *per se* and'. It is an ancient monogram of the letters 'e' and 't', the Latin word *et* meaning 'and'. The *et* in this instance is not reflected in the character on the grid, which occupies nine units in width. The upper bowl is much smaller than the lower with the angle of the diagonal stroke cutting through to form a semicircular counter and the tail ending in a bracketed serif. The upward tail to the bowl ends with a bracketed serif above the centre line.

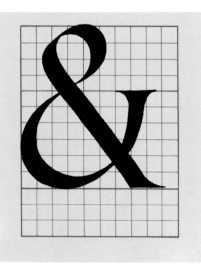

PEN PRACTICE

It is the angle of the nib in relation to the direction of writing and stroke which gives the letterforms their characteristics. A style that is formed with the nib angle at 30° to the writing line will have a different visual appearance to that lettered at 45°. This is because it is the angle that determines the weight of each stroke and the stress of the round letters. Because the angle is maintained from letter to letter, with the exception of one or two strokes, a certain quality and rhythm is created throughout the letterforms.

Because the pen angle is 30°, a vertical stroke will only be as wide as the image the nib will make at that angle and not equivalent to the full nib width. In a round letterform, there is a point at which the whole of the nib width is used due to the pen travelling in a semicircle.

The maximum width of stroke – 'the stress' – will be exactly 90° to the thinnest stroke, which is fortunate for round letterforms because, if the nature of the tool used did not produce this automatically, round letterforms would appear thinner than vertical ones of the same weight. Indeed, when letterforms are freely constructed with a pencil and filled in with a brush, compensation has to be made to the curved thick strokes,

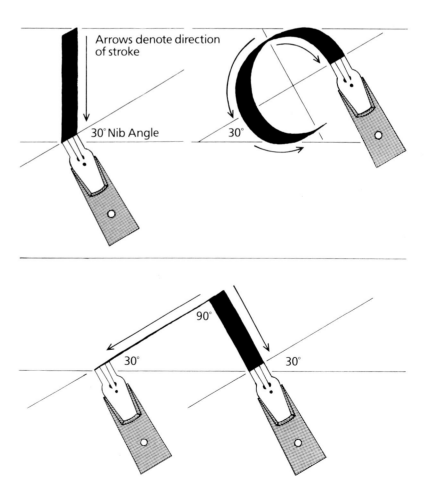

Arrows denote direction of stroke

30° Nib Angle

30°

90°

30°

30°

increasing them in weight to give an optical balance with straight strokes.

Weight of stroke is determined by the angle of the pen and the direction of travel. Diagonal strokes will vary in weight depending on the direction of the stroke. Strokes made from top left to bottom right are more consistent than those formed top right to bottom left. Horizontal strokes are of a uniform width. These variations are acceptable in pen lettering and give the forms a natural, unforced appearance. The alphabet is constructed from common vertical, horizontal, diagonal and curved strokes.

Letterforms within the alphabet have common likenesses and, although there are 26 characters, the strokes that are repeated within the capitals and lower case are frequent. This repetition makes the task easier: once the basic strokes used in letter construction are mastered, the forming of individual letters is relatively simple. The ability to produce the strokes with confidence comes from practising them on layout paper.

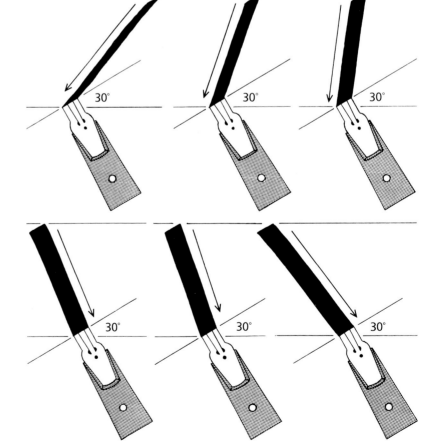

The width of stroke varies according to the direction in which the pen is moved while retaining a fixed nib angle.

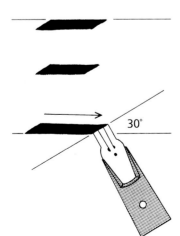

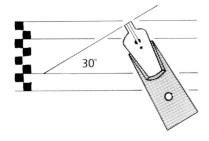

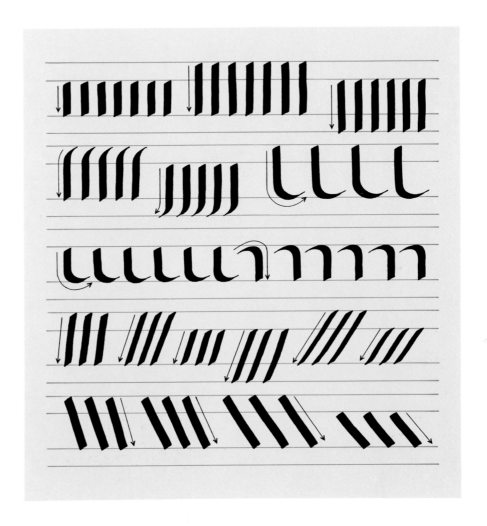

FORMING STROKES

Unlike handwriting, where the pen is lifted from the paper only occasionally between words or necessary breaks in form, calligraphic lettering dictates that the pen is lifted after each stroke. It is the combination of strokes which creates the letterforms.

The pen is nearly always used with a pulling action towards the letterer. Horizontal strokes are made from left to right. The nib should glide across the sheet with just enough pressure to keep it in contact with the writing surface.

It is at this point that problems often face the newcomer to calligraphy. It is essential that the pen angle is maintained while producing the stroke, whatever direction is taken. This usually takes all of the student's concentration and can result in the nib not being in contact with the paper throughout the movement. This skipping will cause an uneven weight in the stroke, and the result will be patchy.

Control over the pen for small letters is with the fingers for the up-and-down movements, with the wrist being employed only slightly for

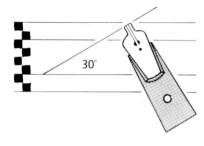

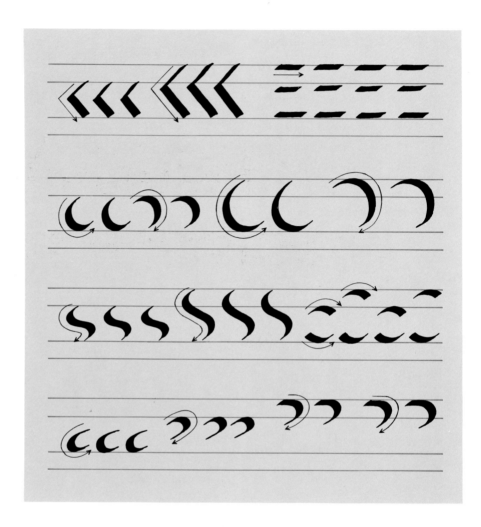

These simple strokes form the basis of letter construction.

rounded letters. When forming larger letters, say over ¾ in (20 mm), the movement is from the shoulder with the whole arm moving down the writing surface. The height of letter at which the transition from finger to arm movement is made is dependent upon the dexterity of the individual.

The exercise requires mainly finger and wrist action with, perhaps, some of the longer, diagonal strokes needing arm movement. The third and little finger rest on the paper and help to support the pen holder.

BASIC LETTER STROKES

Begin by tracing over the forms given in the exercise. To do this, a nib that is of the same size as that used here will be required. Take a nib and compare it with the nib and width of stroke marked at the side of the sample exercise. It will be beneficial if the size can be matched exactly, although a small variation will not matter at this stage. The main aim of the exercise is for the student to become familiar with the action of the pen and to develop a rhythm when forming the images.

LETTER SPACING

Once the student has lettered his first alphabet, it is necessary to consider spacing the letters in order to produce words. This would be an easy task if all the character shapes were either straight-sided or round, as then the same amount of space could be left between them. Unfortunately, the alphabet consists of many different shaped characters; measuring the same amount of space between characters does not produce an aesthetically pleasing word. Instead reliance must be placed on optical spacing and fine adjustments.

Letter spacing is one of the most difficult aspects of lettering. Calligraphy, signwriting, using pre-cut letters or lettering proper (that is, with a brush on paper or board), all these forms of communication require good letter spacing if they are to achieve their aim of informing in a legible and attractive manner.

The characters of the alphabet can be divided into four main groups: straight-sided, rounded, open and oblique. Some fall into more than one group; for instance, the capital and lower case 'C' are both rounded and open. As a guideline, think of round letters as being close-spaced and straight-sided letters as being the widest spaced. Consider these two groups. A vertical letter in its simplest form is the 'I' and a round letter the 'O'. If the combinations of IOOI and OIIO are looked at, the difference in spacing, can be seen. The first line lettered is spaced mathematically, the second optically. The difference is that optical spacing takes into account the nature of the 'O', with its round shape giving a greater amount of white area than a straight-sided letter. It is this counter-space which must be considered. The golden rule is not only to appreciate the shape of the letters but also the white areas that they create around them. These are just as important as the forms themselves, and the student cannot commit himself to a letterform without being concerned with the areas they create.

The aim of the letterer is to produce even areas of white space between the letterforms. This will take time to learn, and experience only comes through a rational approach to spacing. A letterform's space requirement must be evaluated before committing pen to paper in order to achieve harmony.

inn
INN
Straight letters-wide spaced

boo
BOO
Round letters-close spaced

reef
REEF
Open letters-fairly close spaced

avail
AVAIL
Oblique letters-close but variable

IOOI OIIO

IOOI OIIO

DETERMINING WHAT SPACE TO USE

Once the student has lettered his first two characters, he has set the criteria which will determine the spacing of all the letters that follow. If the first two characters are straight-sided, they should be lettered with sufficient space between them to accommodate the close spacing necessary for round letters which may follow. Without making this judgement prior to lettering, the rounded forms will be tightly spaced and may even touch each other if the first letters are very close. The reverse

INDOORS
INDOORS

can be said for two rounded characters at the beginning of a word. If they are spaced too far apart, the end result will be an over-spaced word because the straight letters will require extra space to appear optically balanced with their rounded partners.

DOODLING
DOODLING

Open and oblique letterforms vary in the amount of space they require in accordance with the word construction. However, as a rule, open letters are fairly closely spaced because the open counter has to be taken into consideration.

Owing to the letter combinations, the word TALE for example is difficult to space. There are numerous other combinations for which it is almost impossible to achieve total harmony in the spacing and where it is

WYVERN
WYVERN

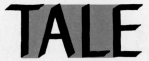

Optically spaced: the shaded areas should appear equal.

necessary to resort to other methods, such as the forming of ligatures or the reduction of the length of stroke.

In the word TALE the cross-bar at the right of the 'T' overlaps the thin diagonal stroke of the 'A'. This is done to reduce the natural space made by both letters and will now set the optical standard for the remaining letters. In order to space the 'L', the area between the 'T' and 'A' must be evaluated and the same amount of space be left between the thick oblique stroke which forms the right of the 'A' and the vertical straight stroke of the 'L'. In order to space the 'E', cover up the 'T' with a piece of paper. This will allow you to concentrate on the positioning of the 'E' without being distracted by the 'T'. Letter the 'E' so that the space left between the 'L' and 'E' is equivalent in area to that between the 'A' and 'L'. If a longer word required spacing, it would be necessary to cover up the previous letter in each case, so that only two letters are visible at any given time, while deciding on the position of the third. This spacing system is known as the three-letter spacing method.

Draw the guidelines with a sharp pencil, 4H or 2H, on a layout sheet, using the proportions for Roman Sans Serif. Letter the following words without tracing: indoors, wyvern, crafty, thirty, effigy. Now compare them with the words in the right-hand column, which are lettered correctly. In the left-hand column the words have been lettered without minor adjustments so that the problems that the letter combinations create can be clearly seen. I have made the alterations necessary to achieve an evenly spaced word. These include reducing the arm of the 'r', undercutting diagonal strokes and substituting ligatures where required.

All preliminary layouts should be scrutinized and any adjustments to letterspacing should be clearly marked as a reminder when producing the finished work.

shorten
arm of 'r'

indoors indoors

reduce #

shorten
arm of 'r'

wyvern wyvern

reduce # reduce #
under-cut oblique strokes.

shorten form ft
arm of 'r' ligature

crafty crafty

reduce #

shorten cross bar form rt
ligature

Thirty Thirty

reduce # −# ()up

form ffi ligature

effigy effigy

reduce #

\# = Space
+\# = More Space
−\# = Less Space
()up = Close up

26

WORD SPACING

The extension from a single word to a line of text requires word spacing, that is, the amount of space left between one word and another. Word spacing is strongly linked with letter spacing in that if too much space is left between words the rhythm of the line is broken, leading to poor readability. The amount of space used must be consistent if continuity is to be achieved. Therefore, it is necessary to have a unit of space which is regular throughout the line and a simple system to determine the amount of white to be left.

Again, there is no mathematical answer for achieving even units of space, as the letterforms differ in shape and optically vary in counter areas. Word spacing must therefore also be based on visual judgement by using a capital 'I' for space between words in capitals and a lower case 'i' for lower case words. These 'i's are letter spaced between the words to give the same optical value. In effect, a complete spacing system has now been outlined.

The words in a line of text should be treated as a complete word. In the example, a capital 'I' has been inserted between the words and high-lighted in red to illustrate the system. When a line of text is word-spaced, the 'I' should be lettered using a carpenter's pencil which has been sharpened to a chisel edge the width of the pen nib, simulating the pen stroke width. After a line is completed, erase the pencil to give the finished result. Once the student has become familiar with word spacing, he need no longer use the pencil.

Draw up guidelines on a layout sheet using the proportions for Roman Sans Serif. Letter the example using the above method and compare the results with the sample lettered here.

THEISPACINGITOIUSE

inithespacingiofwords.

When lettering more than one line of text it sometimes becomes necessary to add extra space between lines. This is known as interlinear space. The main reason for this additional space is to prevent the descenders of one line from clashing with the ascenders of the line below. Even half a nib width of space inserted between the lines can eliminate the problem.

Both legibility and readability are determined by sensitive spacing.

Both legibility and readability are determined by sensitive spacing.

The style of lettering used will affect the amount of space required. If the style has a large x height with small ascenders and descenders, it will need more interlinear space than a style that has a small x height with long ascenders and descenders. This is because the latter creates more open space between lines of text owing to its larger ascenders and descenders,

Continuous text requires discerning interlinear space.

Continuous text requires discerning interlinear space.

and thus requires minimal interlinear space – if any – provided, of course, that characters do not clash. In some instances, it may be possible to reduce the length of ascenders and descenders to avoid clashing, but this should be treated with caution where letterforms with short ascenders and descenders are concerned.

As a guide to the amount of interlinear space required, the space between x heights should never be less than the x height of the style being lettered. This rule obviously refers to large x height, small ascender and descender styles.

The Roman Sans Serif style falls into this category, having a four-nib-width x height and two-nib-width ascender and descender proportion. If the proportions were, instead, five-nib-width x height and two-nib-width ascender and descender, it would be necessary to insert interlinear space to give the lines optical room to communicate their message efficiently.

The readability of a text is dependent upon letter spacing, word spacing, line length and interlinear spacing. The eye travels along a text from left to right, scanning a line before moving down to read the following line. If interlinear space is insufficient, the eye has difficulty in moving down a line and it is easy to end up re-reading the line just finished. Nevertheless it is not always the space between the lines which produces this effect. Often the line length is too great, and the eye has to travel too far back to pick up the next line, resulting in the line being missed or the same line being read twice.

Letter spacing and word spacing have been covered from the practical viewpoint, but the reasons for specific space being used have not yet been discussed. The eye is conditioned to recognize letter patterns; that is, individual characters are not 'read' in a word, but rather the pattern that they create. The wide spacing of letters and words hinders the reading rhythm. The effect of over-spaced words is to make it difficult to follow the line and often the reader jumps to the line below. This normally happens when the word space is greater than that of the interlinear space. Always consider both when producing continuous text, making the reader's task an interesting path to follow, without these stumbling blocks that can quite easily be avoided.

As the amount of characters to the line is so important, it will be discussed again later. However, for the time being, if the student notes that between eight and twelve words per line is an acceptable length for readability, he will not go far wrong.

This style is based on Edward Johnston's Foundational Hand, which was modified from a 10th-century manuscript. In construction it is similar to Roman Sans Serif, but with the addition of serifs to give the style its character. These serifs are formed either by a change of direction, as in the serif at the foot of the thin diagonal stroke of the 'A', or by a second curved stroke into the main stem, such as that at the cap line of the 'B'. There are also tapered terminals, which are formed by a curving of the stroke ending at the pen angle, giving a point. This can be seen in the main stem of the 'A'.

The alphabet is lettered at an angle of 30° throughout with the exception of the capitals 'N', 'X' and 'Z'. The angle for both vertical strokes of the 'N' has been changed to 45° to give a slightly thinner stroke. The thin diagonal stroke of the 'X' has been lettered at 15° from the horizontal in order to give the stroke some body and keep it more in line with the thin diagonal strokes of the 'V' and 'W'. The 'Z' is the only letter that, when lettered with a 30° angle, has a main diagonal stem which is less in weight than the horizontal strokes. I feel that this anomaly should be overcome and have therefore adjusted the angle to 15° from the horizontal to give the stroke some stature. The lower case 'z' also requires this change.

As a guide, if the main strokes of any letter are regarded as being the trunk of a tree, then all other strokes emanating from the stem should be of a weight that the main stem can support. This, I hope, explains my concern with the letter 'Z'. All these above adjustments have been made to give the letters concerned a better relationship with other characters – to achieve harmony and continuity.

However carefully the letterforms are drawn, there will undoubtedly be a slight deviation from the 30° angle. Provided that it is only minor, it will not measurably affect the end result.

The guidelines should be drawn as indicated at the top of the first page of the alphabet. The numerals fall within the x height area but the student can, if he wishes, increase the size to that of the capitals. However, I prefer them slightly smaller. Most of the characters are lettered with finger movement only, although the longer strokes may need some arm movement coming from the shoulder.

Once the alphabet in its present form has been mastered, the student may wish to letter the style in the following proportions.

	ascenders	x height	descenders
nib widths	2	4¼	2
nib widths	2½	5	2½

This exercise is well worth the effort as it will show how a letterform changes in character when minor proportional adjustments are made. The alphabet style should, nevertheless, retain its general appearance and flavour once the nib values are changed. The overall effect of the proportional changes would be to make a page of text appear lighter.

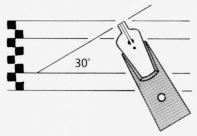

Capital height: 6 nib widths
This alphabet is lettered with a B4,
the metric equivalent being a 2·3mm.

Nib Angle approximately 30°

Arrows denote direction of stroke.
Numerals indicate order of character
construction.

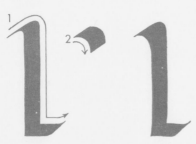

Nib Angle changed to 45° for the
vertical strokes of the N.

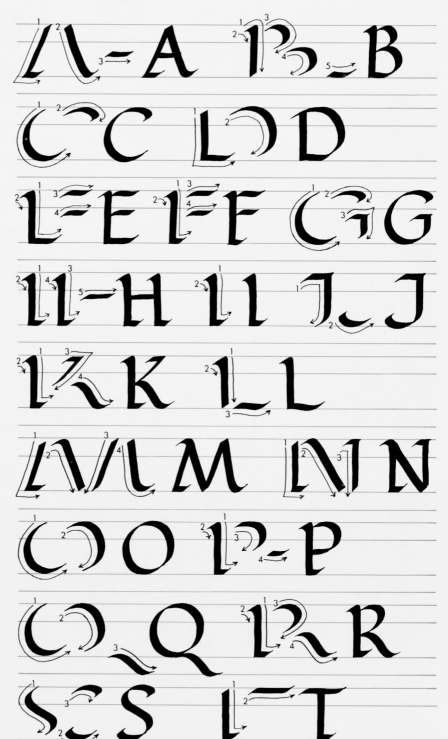

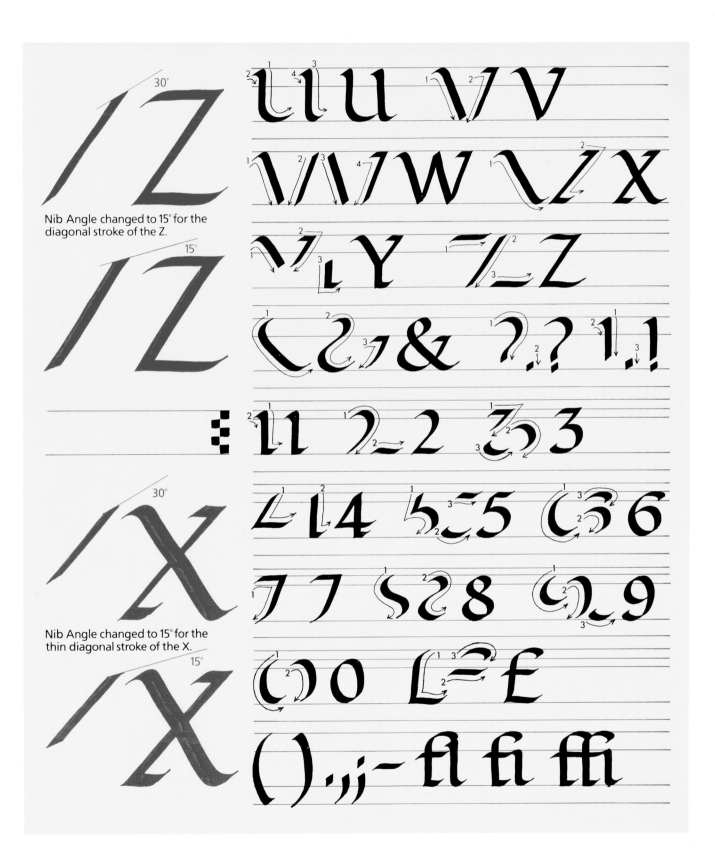

Nib Angle changed to 15° for the diagonal stroke of the Z.

Nib Angle changed to 15° for the thin diagonal stroke of the X.

Ascenders: 2 nib widths

'x'height: 4 nib widths

Descenders: 2 nib widths

30°

15°

ITALIC ALPHABET

Italic is a compressed style from the Renaissance period, developed by Italians from classical manuscripts of the ninth century and enjoying great popularity during the 15th and 16th centuries. It is a suitable hand for large quantities of text as it can be produced with speed and makes economical use of space.

It has an inclined angle to the right, which can vary from a few degrees to 13° from the vertical. After 13° the pen forms produced are not balanced, with straight and curved strokes differing greatly in weight.

Compression of the letterforms lessens the width differentiation between characters: the capital and lower-case 'M' are proportionally much narrower than their Roman counterparts when compared to, for example, the letter 'P'. The overall impression of italic is that of lightness and fluidity. The basic key letter in the lower case alphabet is the 'o', the left side of which is apparent in the 'a', 'c', 'd', 'e' and 'g', while the 'b' and 'p' reflect the right-hand side.

Serifs in the capitals are formed either by a change of direction of stroke, or by an upward movement before and after the main strokes. Additionally, serifs are made by overlapping curved strokes over main strokes, such as in the 'B', where the beginning of the curved stroke which forms the upper bowl overlaps the left-hand edge of the main stem. Capitals used on their own are not too successful, especially when elaborately flourished. It is therefore preferable to use plain capitals to maintain legibility when using them to emphasize a text.

Lower-case serifs are produced in a similar fashion to those of the capitals. Ascenders and descenders can be finished with an extra flourished stroke, either straightish lines curving upwards or rounded strokes ending in a slight hook or merely sheared straight terminals. They extend one nib width above the capital line and three nib widths below the x line. They can be extended beyond these areas as flourishes, but with discretion.

It will take practice before an even inclination is achieved. Build up a rhythm with a line or two of 'z', 'm', 'n' and 'o', as this will loosen up the fingers. Speed is also important in lettering, with each stroke being deliberate but not laboured. Too slow and the stroke will tremble instead of being straight.

There are two kinds of numerals which accompany the style: lining numerals and hanging numerals. The former line up with the capitals, whereas the latter vary. The 1, 2 and 0 are contained within the x height; the 3, 4, 5, 7 and 9 enter the descender area to the value of two nib widths; and the 6 and 8 are lettered to the height of the capitals.

Capital height: 7 nib widths
This alphabet is lettered with a B4,
the metric equivalent being a 2·3mm.

Nib Angle approximately 45°

Arrows denote direction of stroke.
Numerals indicate order of character
construction.

A B

Flourishing should not be at the
expense of legibility.

E G J

K L M

P T V

AA BB CC
DD EE FF
GG HH II JJ
KK LL MM
NN OO PP
QQ RR SS
TT UU VV

WW WW VX

YY YY ZZ

Z & & ??!!

Lining numerals

11 22 33 44

55 66 77

88 99 00

Hanging numerals

1234567890

a a b b c c
d d e f f g g
h h i i j j k k
l l m m n n o o
p p q q r r s s
t t u u v v w w
v v x x y y z z

b b d d

e e f f

g h h

p q q

r t x

38

BLACK LETTER ALPHABET

Black Letter, Gothic or Old English as it is sometimes called, is a very condensed, upright style, elaborate and, in many examples, extremely difficult to read.

However, from the 10th to the 15th centuries it was the main style in use. It is difficult to imagine the reason for adopting this style in preference to Uncial or Half Uncial forms. Many believe that one of the reasons was speed, but I find this hard to accept. A style that requires five directional changes to form the lower case 'i' cannot, in my opinion, be easier to produce than its Half Uncial counterpart. I would, however, agree with another school of thought which maintains that the style was introduced as a space-saving measure. It is very economical in its use of paper because of its compactness. During the period that Black Letter was popular, there was a greater requirement for documentation and literature; so it follows that a style that required less space to convey a message would be preferred.

The style in its basic form can be regarded as vertical lines spaced the width of the stroke apart and joined together with hairline strokes. The letterspacing should be close – even to the point of touching – in order to achieve a good texture to a page.

The nib angle is 45° and at the beginning of each stroke there is a hairline serif. This is produced by moving the nib sideways at the lettering angle before changing direction to start the first thick stroke. The reverse is the case for a finishing hairline stroke. It should be noted that the direction of nib is changed three times to make the average lower-case stem with a movement towards the left, giving a slight rounding at the bottom-right side for a left-hand stroke, before finally changing direction to meet the base line.

The capitals are formed by multiple strokes. It will help students if the individual movements are traced, and the letterforms built up in this manner. This method will improve judgement of the amount of space to leave for the hairline and embellishing strokes, and assist in the accurate positioning of those strokes that join. The capitals should never be used on their own as the resulting pattern will be illegible.

Although Roman numerals were used in conjunction with Black Letter, I have included a set that I feel complement the style. There are many different examples of the form, a large proportion being fairly decorative. One of the exponents of the art was the German calligrapher and type-designer, Rudolph Koch, who produced some quite plain examples of the style while still retaining the original strength and character of the letterform. Black Letter does have a certain charm and is probably one of the few styles that is comparatively well known; it is often referred to as Old English.

Capital height: 7 nib widths
This alphabet is lettered with a B4,
the metric equivalent being a 2·3mm.

Nib Angle approximately 45°

Arrows denote direction of stroke.
Numerals indicate order of character
construction.

Use edge of nib for vertical hairline
strokes.

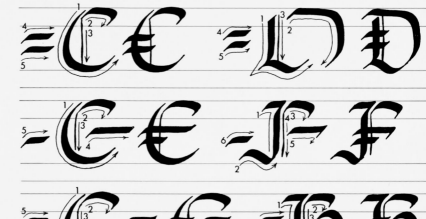

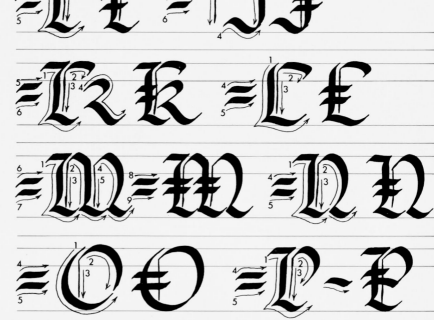

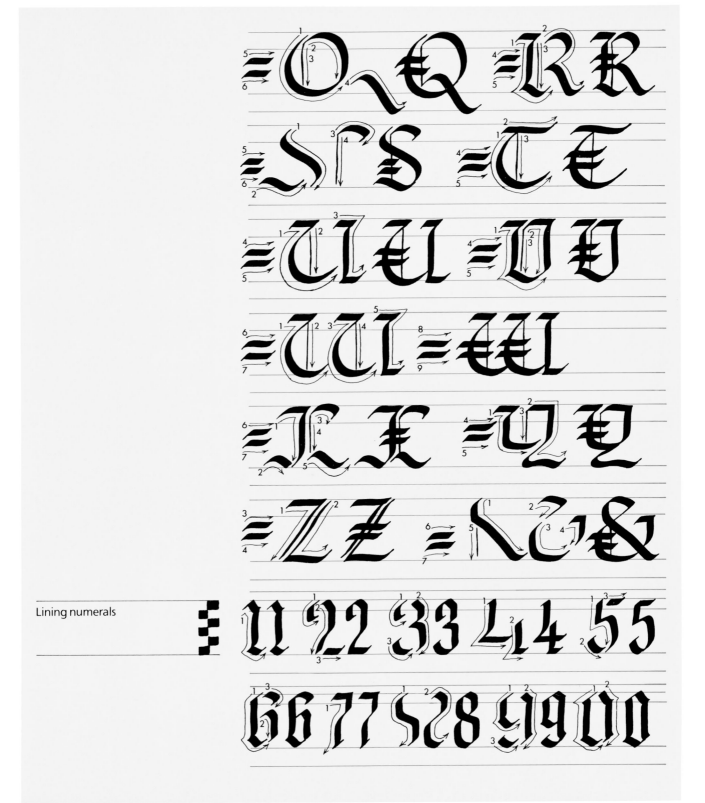

Lining numerals

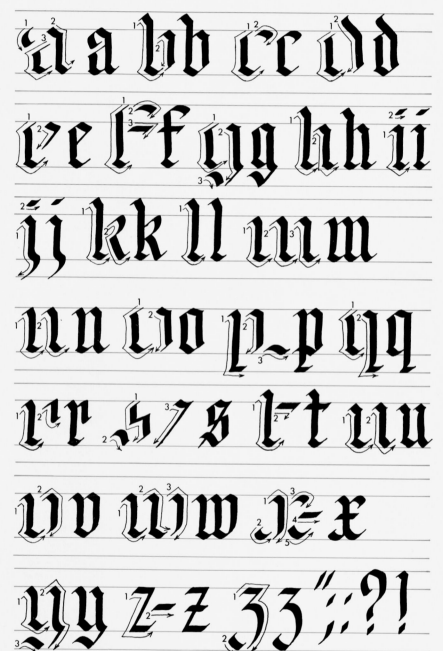

Gothic requires close letter and word spacing to produce an even texture.

CLASSIC ROMAN ALPHABET

This style has been included as an alternative to the traditional Roman form, Quadrata, which is an extremely difficult letterform to produce with a pen. To form the serifs requires many strokes using just the edge of the pen. However, with this Classical Roman alphabet, the serifs have been simplified for ease of lettering with the pen; so it may not be a true classic Roman but will pass as a pen-rendered version. Here the serifs are either formed at the end of a curved stroke by slightly hooking the pen or by a completely separate stroke, lettered at a shallower angle than that of the main stroke construction.

The letterforms are made with a pen angle of 30°, with a few exceptions. The vertical strokes of the capital 'N' are lettered at a nib angle of 45°. This steeper angle means that the vertical strokes will appear narrower, and the contrast of weight is more in keeping with other letters in the alphabet. The diagonal strokes of both the capital and lower-case 'z' also have an adjustment to them. Here the main stroke is lettered with the pen angle parallel to the horizontal, giving the main stem more body.

The horizontal serifs are lettered at a pen angle of 20°, which gives a reasonable proportion with the thin strokes in the alphabet. The serifs on the upper main stem of the 'B', 'P' and 'R' are extensions of the thin cross-strokes which form the upper bowls of each letter. Where white areas are left between serifs and main or thin strokes, they should be filled in afterwards.

The accompanying numerals are lining numerals, lettered to the capital height. Hanging numerals may, however, be used, should the occasion arise.

When lettering in Classic Roman, a simple, centred layout is often all that is needed. The letters speak for themselves.

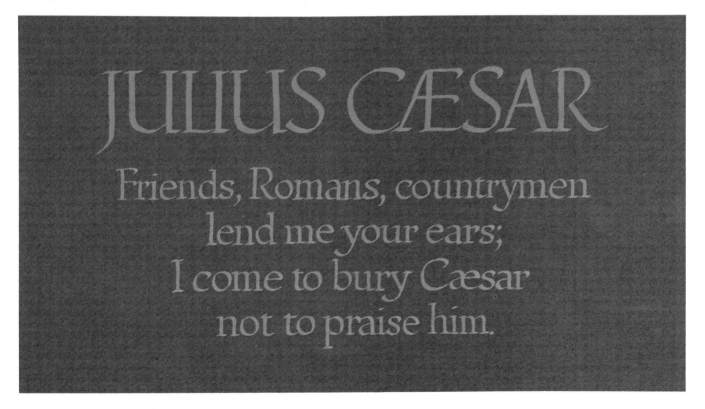

Capital height: 10 nib widths
This alphabet is lettered with a B4,
the metric equivalent being a 2·3mm.

Nib Angle approximately 30°

Arrows denote direction of stroke.
Numerals indicate order of character
construction.

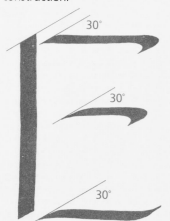

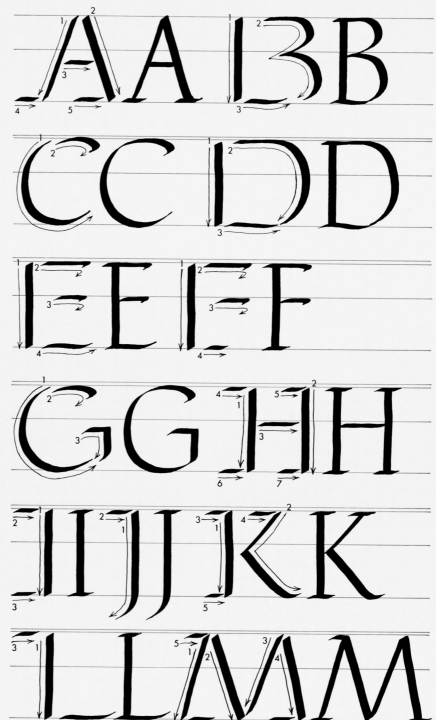

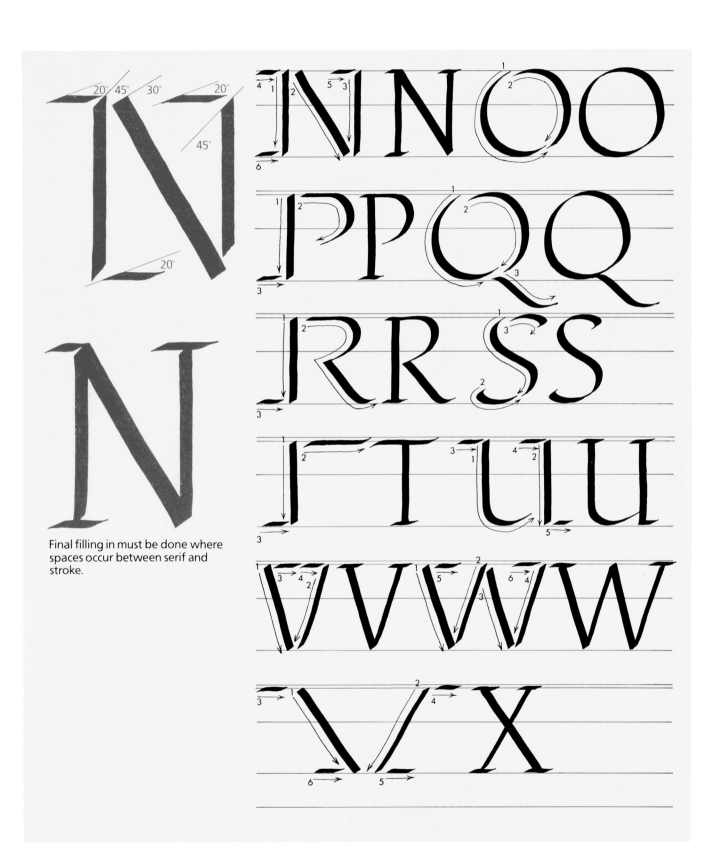

Final filling in must be done where spaces occur between serif and stroke.

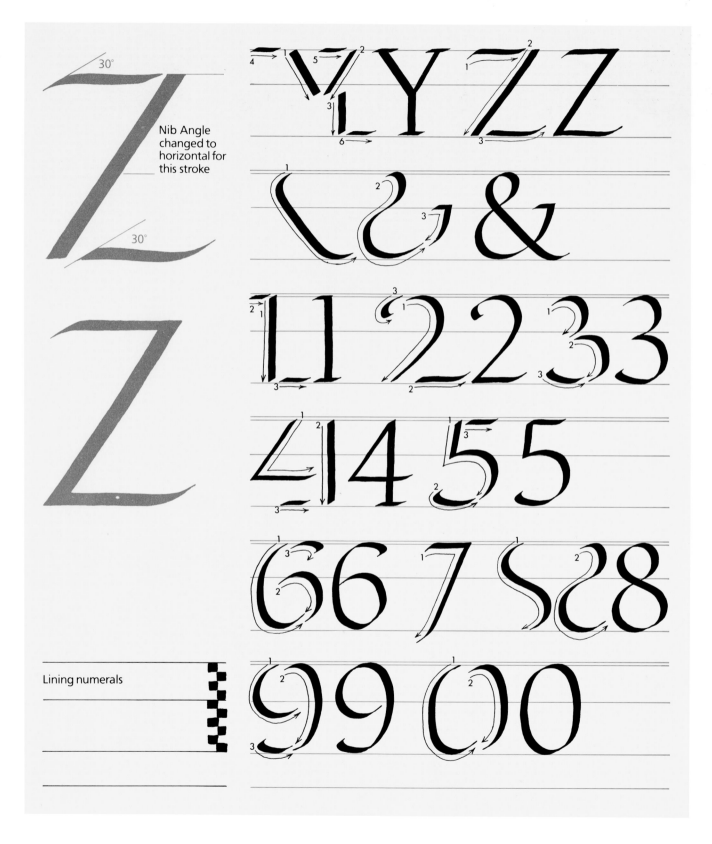

Nib Angle changed to horizontal for this stroke

Lining numerals

Ascenders: 4 nib widths

'x' height: 6 nib widths

Descenders: 4 nib widths

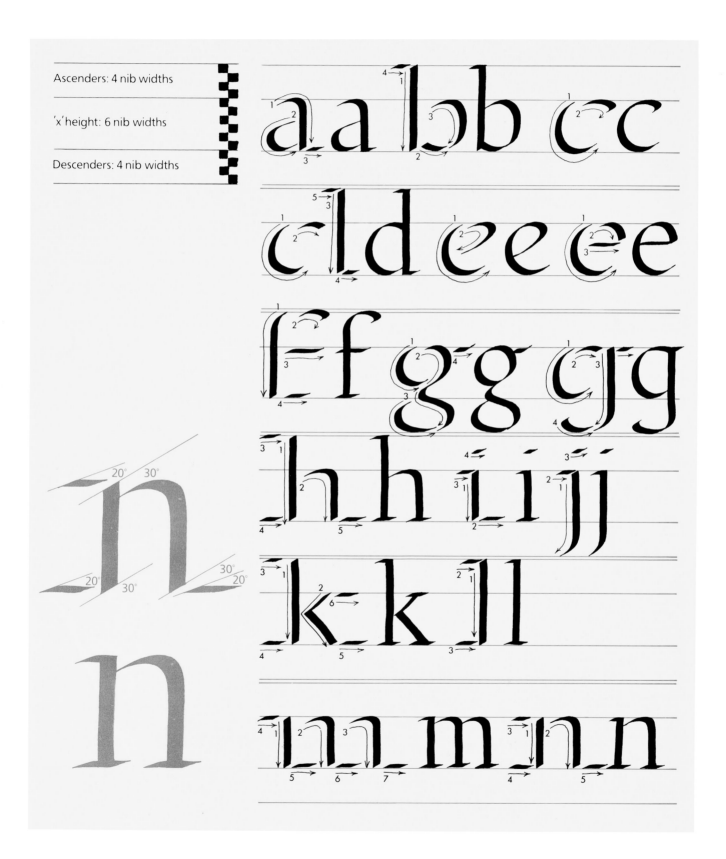

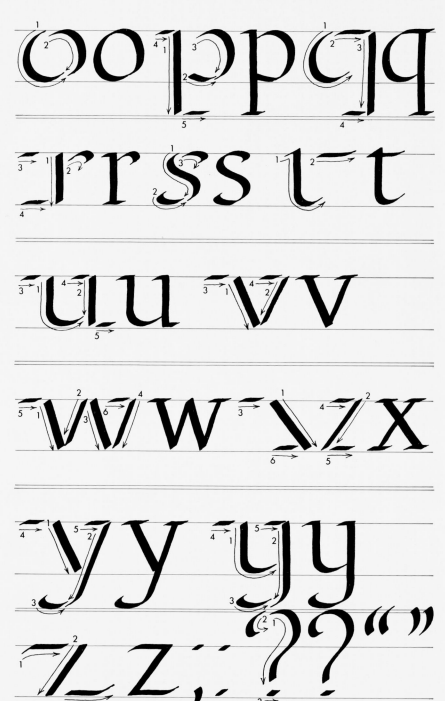

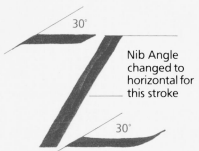

30°

Nib Angle changed to horizontal for this stroke

30°